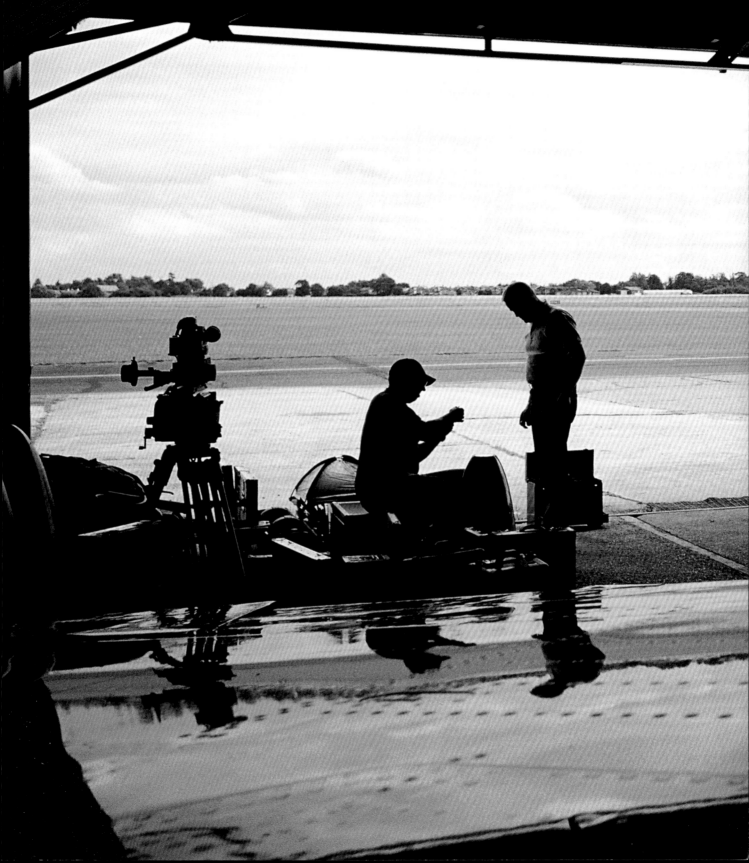

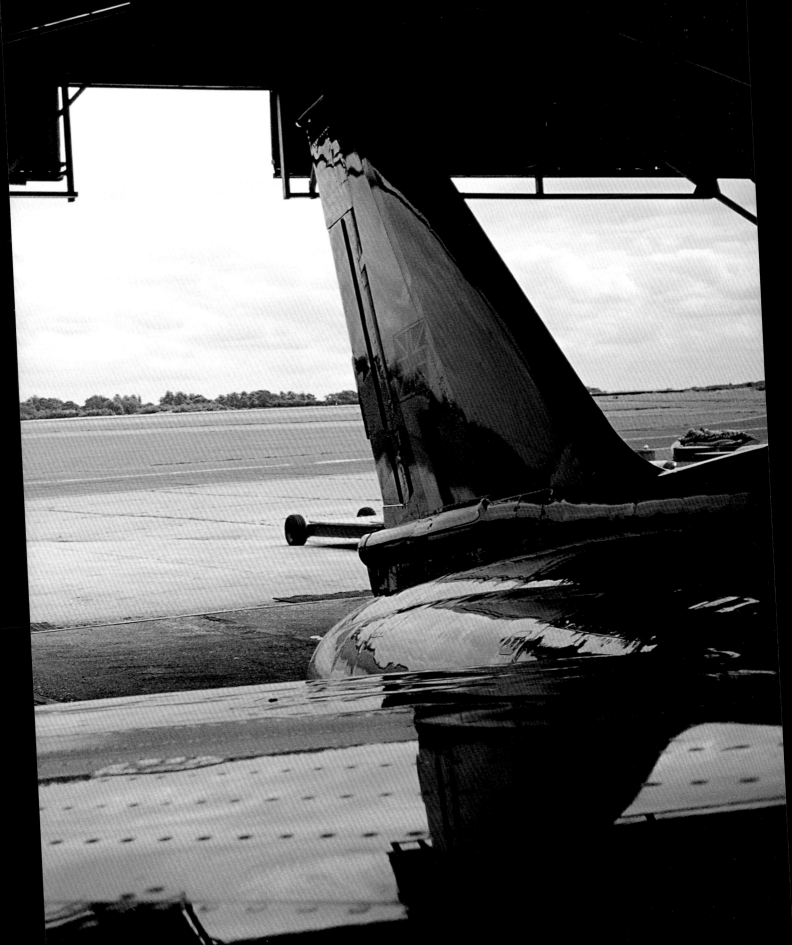

Cornford & Cross
Childhood's End

Edited by Simon Willmoth

Film and Video Umbrella/Norwich School of Art and Design

previous pages:
Childhood's End
2000
production still

Collaborations between artists allow a complexity and speed of development of new work that is particularly appropriate to our age. Cornford & Cross first worked in Norwich when they were selected by Tacita Dean and Nicholas Logsdail for 'EAST' in 1997. The work they produced, *New Holland,* combined a formal sculptural exercise with a critique of the interests invested in the site at the Sainsbury Centre for Visual Arts.

Cornford & Cross were selected for 'EAST' on the strength of a single image of *Camelot*, the work they completed for 'City Limits', an exhibition organised by Staffordshire University in1996. The following year at the Norwich Gallery exhibition 'Oktober 1917–1997' they showed a video of Russian 'brides for sale' from a US internet site. The work was later developed for 'ISEA '98' as *Cosmopolitan*, depicted in a memorable image of the piece projected at twilight on a screen at the back of a shipping container parked at Liverpool Docks.

In 1999 they worked on two projects: *Utopia (wishful thinking)* for 'In the Midst of Things' at Bournville and *Jerusalem* for 'riverside' in Norwich. Both were commissioned with funds from a range of sources, including the Arts Council of England, Regional Arts Boards, commercial sponsorship and Higher Education funding. Cornford & Cross have intelligently and ambitiously used the new source of patronage in art schools in the 1990s, which resulted from the Research Assessment Exercise.

The realisation of several of their projects for ventures developed by regional art schools had the drawback that knowledge of their work in London was fragmented. The Norwich Gallery was interested in finding a form for a touring exhibition of their work and a publication. At the time, Film and Video Umbrella was working with Eastern Arts Board and West Midlands Arts to develop projects in their regions. As part of this initiative, the Norwich Gallery worked with Film and Video Umbrella, showing the Canadian artist Mark Lewis's film *Peeping Tom* in June 2000.

I proposed the idea of Cornford & Cross making a film to Steven Bode, Director of Film and Video Umbrella, recommending the role of FVU in encouraging artists to work in film and video. Cornford & Cross had already been mentioned in Steven Bode's conversations with Sarah Shalgosky at Mead Gallery, University of Warwick. Film and Video Umbrella co-ordinated the successful application to the Arts Council for Lottery Funding and contributed to the development of the film. My colleague Simon Willmoth worked with Cornford & Cross on the publication.

I think we are now convinced of collaboration as a way forward.

7

Editor's note: the interviews and conversations from which the following text is drawn took place on a number of occasions during the preparation, filming and completion of *Childhood's End* in 1999–2000.

Childhood's End
2000
production still

Utopia (wishful thinking)
1999
installation view
restored ornamental pond,
purple food dye and fountains
25 x 10 metres
for 'In the Midst of Things'
Bournville, Birmingham

Simon Willmoth: We could start by discussing the genesis and development of *Childhood's End*.

David Cross: Lynda Morris of the Norwich Gallery suggested over a year ago that we work in film. It was something we'd been considering for some time but hadn't got around to it – our working method is about engaging with a particular site, a space, a piece of territory. Once we started thinking in terms of film we felt rather adrift for a while until we began to relate to film as a spatial experience, as a way of approaching the project.

Matthew Cornford: We had often referred to film and cinema but felt quite discouraged by the number of people and the sums of money involved. However, the organisation and financing of this project has been very similar to our other projects. The language used in film translates quite well to the way we work, in the way we get involved in finding locations, producing and directing photo shoots. I only fully realised this when we began to work with Steven Bode and Mike Jones at Film and Video Umbrella.

SW: How does this project relate to the 'Utopias' exhibition at the Mead Gallery?

DC: The last project we'd done before being invited by the Mead Gallery to take part in the group show 'Utopias' was a site-specific installation at Bournville for the group show 'In the Midst of Things' (1999). The work we did there was called *Utopia (wishful thinking)*. We'd been thinking about the inaccessible and fragmented nature of Utopia as a social construct, and the problems caused when people try to realise an unattainable ideal. Our project at Bournville set out to be simple, ideal on one level, but the technicalities of producing it were horrendous.

MC: The title of the Bournville project got changed quite a bit as the work developed but 'Utopia' summarised a dimension of what Cadburys originally attempted. It is an interesting place and a positive social experiment, but we had to qualify the reference to Utopia.

SW: *Childhood's End* also went through a number of changes and refinements during the period of the project: which aircraft to use, the positioning of the cameras, for example. But the idea of sky-writing seemed to be there very early on.

MC: *Childhood's End* has been different from our other projects where we've identified a particular site or situation, but in film anything is possible and there are decades of film and television imagery to contend with. One of the things we thought about early

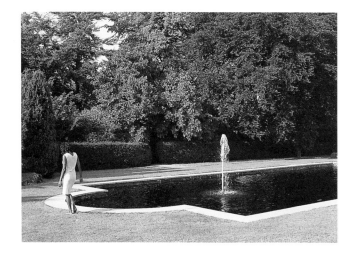

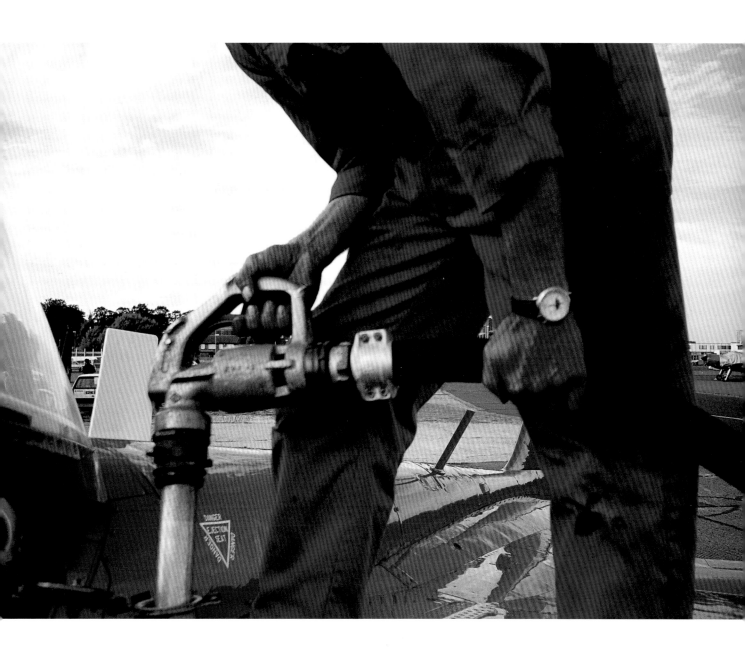

Night Mist
1994
ink on canvas and Calais lace
5 x 5 feet
for 'Interpretations'
Folkestone Library Gallery
1994
Milton Keynes Gallery
2000

Tonight the stars
1994
photographic print
12 x 16 inches
for 'Interpretations'
Folkestone Library Gallery
1994

Anarchy symbol
London
2000
artists' reference photograph

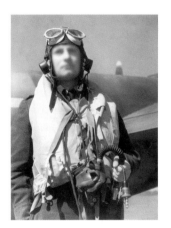

on in the project was blue sky as a clichéd metaphor for escape, aspiration to something bigger and better above us. Originally we were thinking of the circle, square and triangle as identified by the Bauhaus, written in the sky and dispersing. However, we felt that playing out the death of modernism is not a particularly useful or interesting thing to do any more. The idea also didn't have the kind of edge we like our work to have.

DC: A lot of interconnected discussion took place over several months, and there was quite a struggle to establish some parameters for the project. At one stage we thought that a large, sumptuous image of clouds drifting past in the sky would be useful, because it is boundless. We related this to the opening sequence of Leni Riefenstahl's *Triumph of the Will* (1934), with the view from a plane descending through sunlit clouds towards a peaceful landscape. We also saw a connection to works we made for the 'Interpretations' exhibition in 1994, where the 'clouds' were explosions of night bombing raids over Northern France. One aim of these works (*Night Mist, Electric Night,* and *Night Dancer*) was to engage with how photographs from reconnaissance flights and from bombing raids are used as evidence, while acknowledging that they have a severe beauty.

Another of the pieces in 'Interpretations', *Tonight the Stars,* was based on a propaganda image of an Allied pilot from the 1940s, a photograph which had lost its meaning for the Imperial War Museum.

MC: We got that photograph from a sale of images which the Museum no longer knew where to file. The caption on the back had been changed so many times over the years that they no longer knew where the photograph was taken or the identity of the pilot.

DC: We partially erased his features, blurred and softened them, so it suggested a dream state, perhaps, or plastic surgery after severe burns; a loss of memory and a loss of face. We were thinking about how the individual relates to the system and the relationship between the propaganda image and the family album photograph; bringing together the official history and personal memories of being involved in armed conflict. The title might suggest superstition or faith in destiny as much as using fixed reference points in space for navigation.

SW: Was the idea of sky-writing linked to images of smoke trails tracing the dogfights of the Battle of Britain?

MC: Paul Nash's painting *Battle of Britain* (1941) was a particular inspiration; we feel a strong affinity with his work.

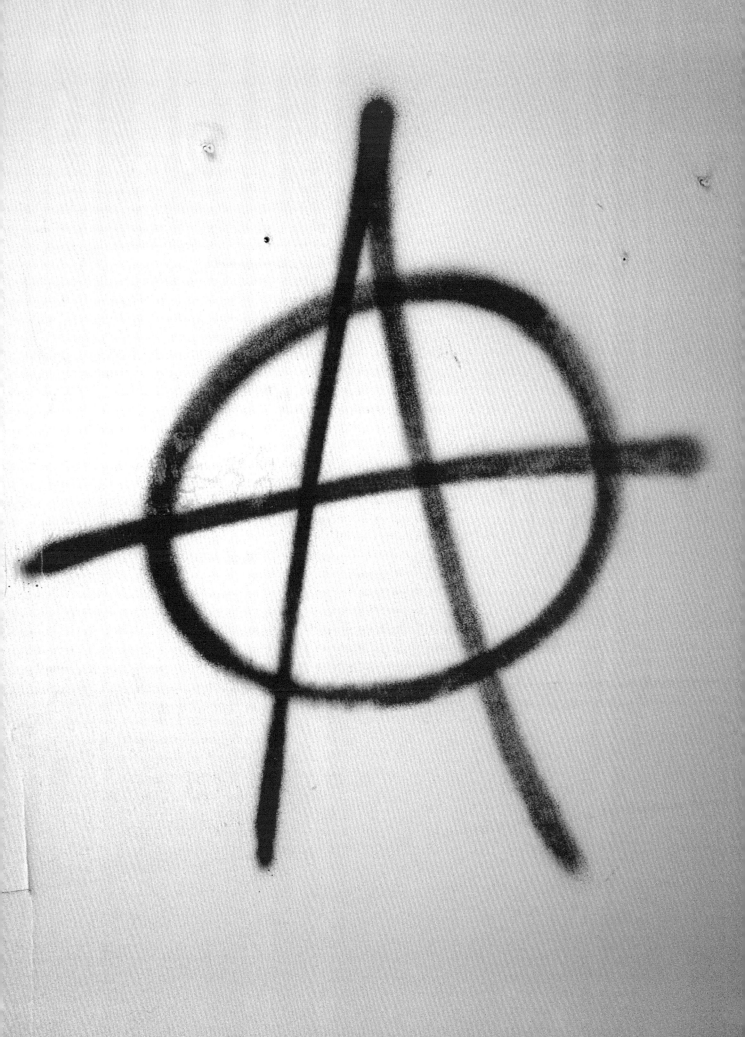

Childhood's End
2000
production stills

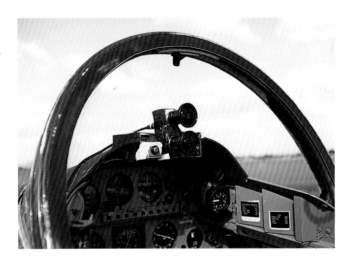

SW: As well as the 'Bauhaus' circle, square and triangle, the Picasso signature and 'The End' were also considered before deciding that the Anarchy symbol would be what was written in the sky for the *Childhood's End* project.

MC: A key thing with us is that we like to do it for real. It is impossible for an aircraft to execute a Picasso signature in the sky accurately, for example. Although we considered a number of symbols and words, the Anarchy symbol works much better in a number of ways.

DC: The impulse to deface something could be expressed in a hastily scrawled signature, but as a gesture the Anarchy sign is more succinct, it's international and originally deeply transgressive. Anarchy as an ideology is never endorsed by the State, although recently it has been co-opted by advertising, emptied of content and reduced to a fashion statement.

MC: *Childhood's End* is about using totally the wrong tool for the job, in the sense that it uses a highly skilled pilot and an expensive fighter jet to draw a crude, flawed, totally untenable political statement in the sky. By bringing these incompatible things together a space is opened up. Our projects tend to do this as a strategy, to take things too far.

DC: For me one of the chief paradoxes of the work is that in a war zone civil law is not respected. Military forces often come into those situations where law and order has already broken down; at other times they are used to create chaos as a way of generating advantage for the people whose interests they serve.

MC: The other big change that occurred on this project was that originally it was conceived from the viewpoint of spectators stationed on the ground looking up at an air show. We wanted to move viewers from a passive to an almost active reception of the work, so we decide to position the viewer 'on board' the aeroplane, going along with the manoeuvre.

SW: You've used two cameras to record different viewpoints of the flight.

MC: Yes. We used a small 'lipstick' video camera facing the pilot in the cockpit, and for the outside view of the flightpath we're mounting a Super 16mm cine camera under the left wing on what would be the platform for a weapon.

We want to leave the work open to an extent. The jet goes up and

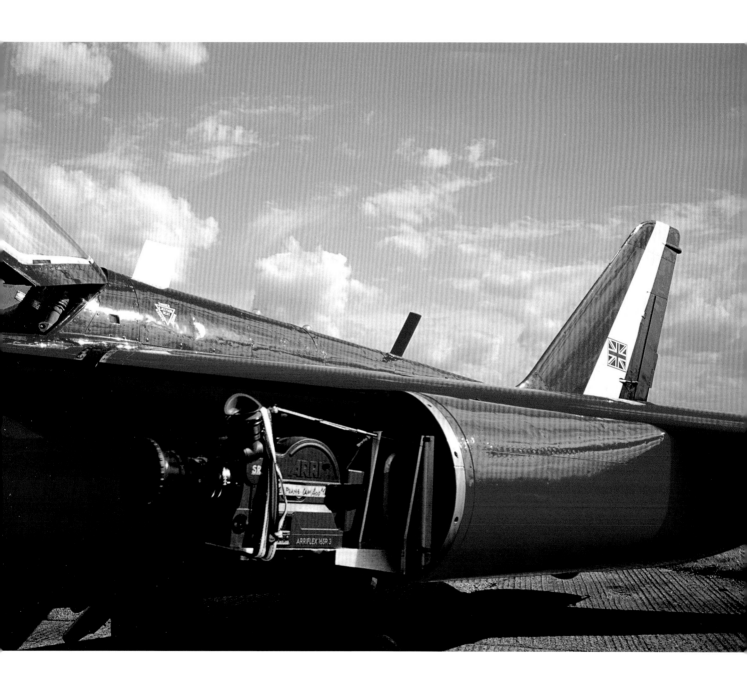

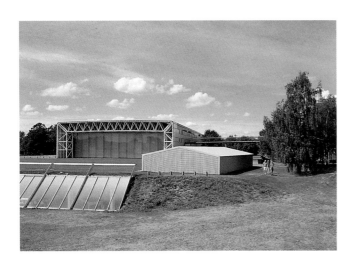

New Holland
1997
installation views
structural steel, steel cladding
and sound system
20 x 10 x 3.5 metres
for 'EAST International'
Sainsbury Centre for Visual
Arts, Norwich

comes down and something interesting happens with the Anarchy symbol being drawn in the sky between these two points in time.

DC: What we're aiming for in the gallery installation is a stand-off, a confrontation if you will, between two different screens, two different types of image. One, a small monitor showing a recording of the pilot's actions. The other, a high resolution image projected onto a large screen, showing the view facing forward from the gun platform of the aircraft. That's the overall impression we want to get: the interplay between the claustrophobic situation of the pilot and the floating openness of his flight path through the sky.

SW: The change of filming the flight from the point of view of the aircraft rather than from the ground may make the viewer more active but having the two screens opposite each other will split the spectator's attention. Not being able to see both screens at the same time, the spectator will have to make decisions about how to view the work and, to an extent, will 'edit' the two films through their spectatorship.

DC: This comes back to our previous works, which have not been just an engagement with context but which have had a spatial or sculptural quality about them. We've noticed this in the way our work relates to and uses photography. An installation can't be seen from one viewpoint or encapsulated in a single photograph, so it is often a series of photographs from a number of different viewpoints which give a clearer impression. The piece we did for 'EAST' in Norwich in 1997, *New Holland,* the large barn-like structure that we built outside the Sainsbury Centre, had to be photographed from at least two points of view, and one of those was artificially elevated. We hired a hydraulic platform to raise us up sufficiently so that we were able to record that piece of work before it was dismantled.

In the gallery, though, the point about not being able to view both screens is partly to encourage a sense of disorientation. You can't be entirely passive and absorb a linear sequence of events as in the cinema. You have to take part, so the experience will be different for every person.

MC: We want viewers to 'edit' the film for themselves. We didn't want to cut from the pilot to the outside, etc., as that would have involved us in a different kind of project which would be about making a film. This is more about recording an event.

SW: So there is a different form of mediation than conventional narrative cinema. Both films are recorded and mediated according to the conditions of their presentation in the gallery.

DC: There is a cinematic quality to the large image but by using two unedited sections of footage we are also referring to conventions of documentation that air forces use and have used. Fixing the camera back on the aircraft, in the place of a machine gun or missile launcher, is like reuniting two long lost relatives in a way. And positioning the 'lipstick' camera inside the aircraft looking at the pilot is not dissimilar to the methods of documenting the effects on test pilots of multiple 'g's' on the heart rate or reflexes.

SW: The link that Paul Virilio makes between the mechanisms of war and cinema also identifies connections between death and entertainment. For example, the notion of the 'cinemachine guns' which he uses in *War and Cinema: The Logistics of Perception* to link the development of the technology of cinematography and of the machine gun. I wondered whether you are interested in other aspects of Virilio's exploration of the experience of space and time as affected by these technologies, what he refers to as 'the logistics of perception'?

MC: Earlier we were concerned with what we saw as the central idea and with working out what the issues were. However, issues of space and the experience of space became increasingly significant as the project developed. The pilot is very confined in the flying suit, in his seating position and in the cockpit covered in perspex. Yet this is so he can fly in a hugely open space, the biggest open space there is. In the gallery we highlight that contrast by having the outside view, shot in 16mm, projected on a large screen the viewer can walk around. The view inside the cramped cockpit is presented on a small monitor.

SW: Conceptually, does that extend to the world being a smaller place through telecommunications, and to people being restricted to smaller social spaces? Again, I am thinking of Virilio's analysis of electronic media's expansion of ocular reality, the reality of visual perception, to dominate other forms of reality/perception.

DC: That's a useful extension. The aspect of the installation which relates to close confinement in a very tight space, suggesting entrapment, is akin to restrictions within the military or some other social hierarchy. Counterbalancing this is the idea of complete exposure, a bit like the polarities of order and chaos, or subjugation and liberation. The installation deploys spatial and visual metaphors of those political and social ideas.

MC: It is also very literal, highlighting what is in the experience of such a flight: a very small space and a very big space.

Childhood's End
2000
production still

Childhood's End
2000
production still

SW: As part of the project you undertook extensive research, which is a crucial part of your practice. In this case it was research into types of aircraft, organisations who could sky-write, the legality or otherwise of sky-writing.

DC: We did look at using a Spitfire early on. Around that time, there was a fatal crash involving an historic plane. There is only a small number of people involved in historic aircraft restoration and flying, and they all know each other. They seem to share a cavalier attitude, a bravado and a strangely stoical response to tragedy. This brought a cold, very serious edge to the project along with the drama and excitement.

MC: Before deciding to work with the people at Kennet Aviation, Cranfield, we went to two other airfields, one in Norwich, one in Epping. At that time our choice was mainly focused on the aircraft; we wanted a particular type of military jet, and Kennet had one that was previously used by the Red Arrows, an archetypal display aircraft with original livery, which was the most beautiful jet that we could use for this project. However, the way we fixed the cameras meant that the plane itself is practically out of the picture.

DC: We had approached the Red Arrows, the Royal Air Force display team, and asked them to carry out this project for us. The phone conversation I had with the Squadron Leader lasted just over one minute. He politely informed me that they have a set routine which is carried out in a programmed season of air shows, and that they never undertake civilian projects, whether for the purposes of advertising or art. That was not for discussion or debate. Very direct.

MC: One of the things that became clear on the day at Cranfield was that filming from the aeroplane rather than from the ground brought together aviation, militarism and landscape which are core themes in many of our projects.

SW: Those themes are most evident in 'Interpretations' (1994), *New Holland* (1997) and *Jerusalem* (1999). *New Holland* linked turkey breeder sheds and RAF buildings.

MC: Those agricultural buildings are based on structures developed for prefabricated aircraft hangars and ordnance buildings in the Second World War.

SW: *Jerusalem*, the child soldier statue resembling a war memorial, is situated in a playing field of a public school.

MC: It is set in a quintessentially English scene: the playing fields, cricket match, the cathedral spire.

16

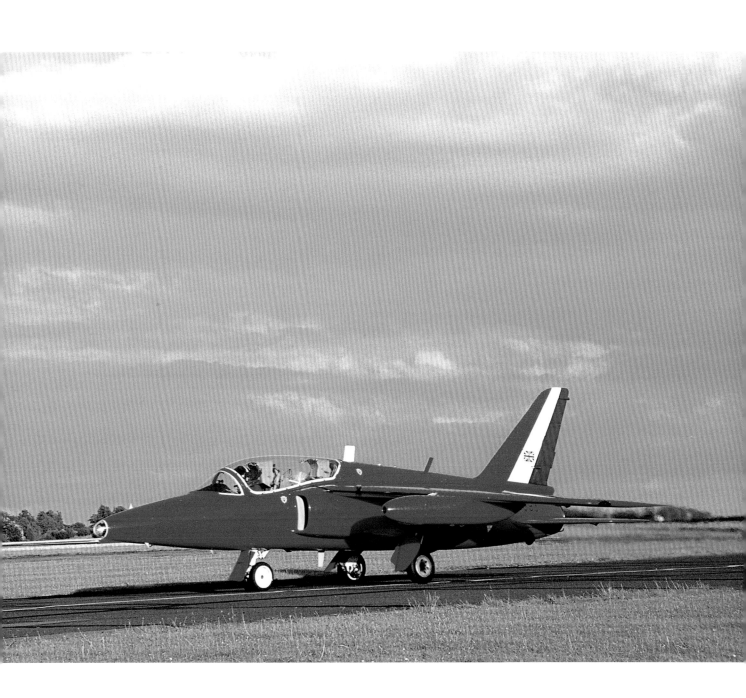

'Figure 11' target
artists' archival material

Take My Breath Away
1993
(detail)
steel security fencing and
printed poster

opposite page:
Jerusalem
1999
(detail)
spent bullet lead on Caen
stone plinth
3 feet x 2.5 feet x 8.5 feet
for 'riverside'
King Edward School, Norwich

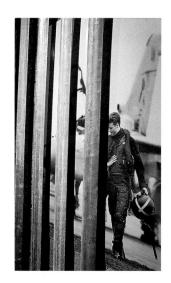

DC: We chose the soldier to be at the ambiguous stage of changing from a child, a boy, into a young man. Obviously if he is old enough to bear arms he is a threat, yet he is just a cadet, a child still at school.

SW: In some respects it reminds me of the 'Paris Match' cover which Barthes analyses in *Myth Today*. You also staged *Take My Breath Away* (1993), an installation at the Metro Cinema in London, which had these themes.

DC: That was about cinema, because *Take My Breath Away* was the theme tune of *Top Gun*, a blockbuster Hollywood romance about the adventures of an American fighter pilot which boosted recruitment for the U.S. Air Force. Our installation explored the political effect of fantasy heroes in cinema.

MC: For the exhibition invitation we used a British Army 'Figure 11' target, which they have since replaced with an abstract bullseye.It was seven inches square and we put it in a seven inch single sleeve. So there's a relation between youth culture and aspirations to freedom mixed with militarism. There were a number of things in that project that we've drawn upon subsequently. For example, the installation included a large piece of fencing, which was like the fencing we used for *Camelot* three years later.

DC: With hindsight the area of concern was valid, but we tried to encompass too much in one piece of work and it became rather overloaded.

MC: It did deal with aviation, cinema, militarism, youth culture and boundaries, so it's connected to much of our subsequent work.

SW: Documenting the process and the installations is an important element of your practice, using photography principally but also keeping letters, drawings, contracts, etc..

MC: When we start a project we often take photographs of a particular site. We also have lots of discussions. For the current project we have taken photographs of air fields, and different planes. We can end up with hundreds of slides which record different stages of the project and quite a large number of photographs of the installation. That is something that runs through all the projects; it was certainly the case with *Jerusalem*. The initial photograph which drew our attention to the site was by Deirdre Grierson, a local photographer, which was on a greetings card we bought in the Norwich Cathedral shop.

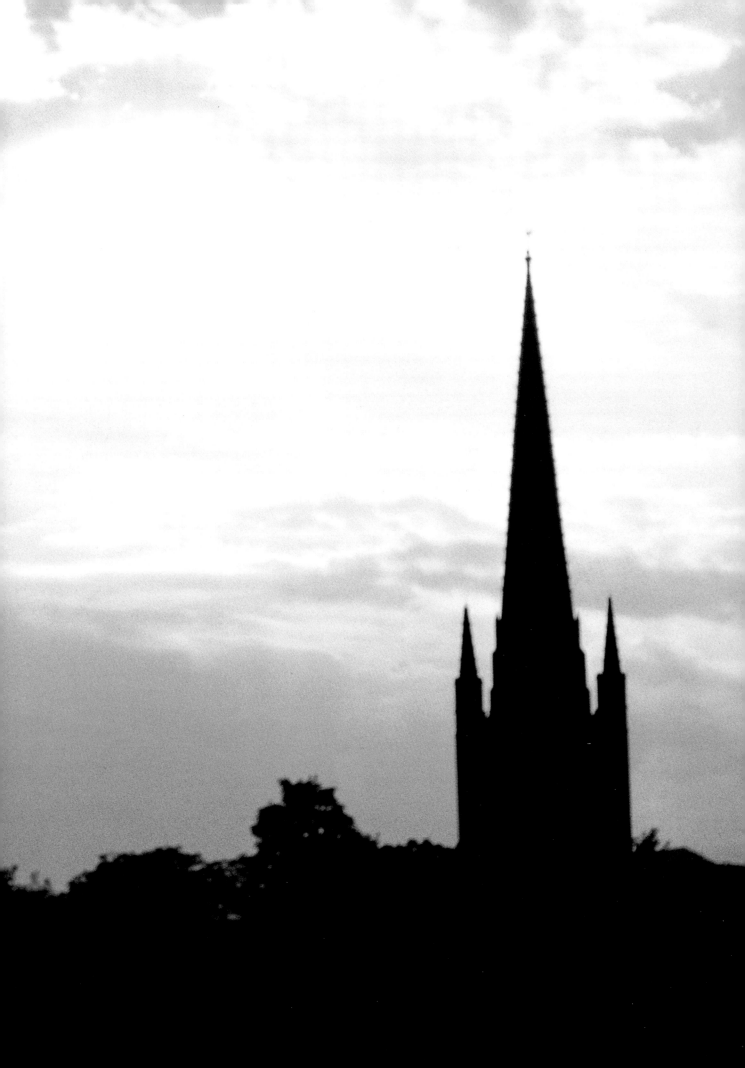

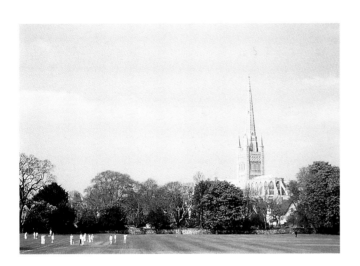

Greetings card
1998
photograph by Deirdre Grierson
artists' archival material

DC: Because we focus on the outcome of a project, it can appear to be the sole purpose of the activity but there is a fluid and close attachment between the documenting of the process and the finished result. The way we work is through a process of interaction, involving letters, phone calls, visits, photographs and drawings to communicate with the people involved.

MC: However, because of the transitory nature of most of the work it is located in photography. The photographs of the installations are how most people have an overview of our practice. *Jerusalem* is the only work still in place.

DC: The other installations have been dispersed back into the commodity system. For example, the barn is now a cattle shed and the fence borders a school playground.

SW: Interest was shown in buying the *Jerusalem* piece but you turned it down.

MC: We wouldn't show the statue outside the context of the school playing field where it is placed. However, a photograph is fine because it shows the cricket match, the playing field, the cathedral, the particular sky of the day and, of course, the work. For our contribution to 'Look Out', curated by Peter Kennard, we made a large framed photograph on canvas of *Jerusalem*, with two smaller photographs of the production of the statue and the original text alongside it. It seems a legitimate way to show that work.

DC: There are other works, like *Cosmopolitan, 10* or even *Camelot,* which could be relocated, but we felt that to move *Jerusalem* would be to destroy it because it is absolutely locked into its context.

MC: But we have redeployed the strategies for those projects in other locations.

SW: Your projects usually involve co-ordinating a number of different bodies and using the skills and knowledge of non art specialists. Has this been the case with *Childhood's End*?

MC: Absolutely. Almost all the projects have required the involvement of people with specialist knowledge and have benefited from the enthusiasm and commitment of technical experts, like a software engineer, fighter pilot or architect.

DC: These people often contribute far more than they're contracted

Childhood's End
2000
production stills

to, they really do put their whole weight behind the project. It is one of the things that sustains our practice.

MC: We're used to working with one or two different organisations, but with this project there have been five or six interested parties involved. So, the ability to manage a team is core to this practice. It's not without problems sometimes, for example on *Childhood's End* some of the people we worked with are creative professionals with their own view of the project.

SW: Your practice is to continually discuss, rethink, adjust elements, and come up with solutions while working on a project. Sometimes your ideas change faster than your ability to keep all the parties involved informed.

MC: *Childhood's End* changed more than our projects usually do, for various reasons, not least that we were using film.

DC: That did produce particular tensions. To produce this work, we were collaborating with other people. We persuade people of the validity of what we are trying to achieve and they apply the best of their skills and knowledge to realise that. Communicating with these people is extremely important.

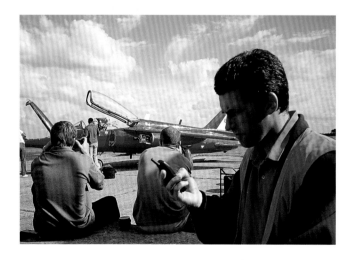

MC: We communicate between ourselves rapidly and fairly constantly, using a shorthand developed over a number of years. So we tend to be several stages further ahead with a project than anyone else.

For *Childhood's End* we received a lot of advice about how much easier it would be to make the work on a computer. One of the reasons we filmed from the aircraft was that it wouldn't be quite so easy to reproduce on the computer. As the project progressed we became increasingly convinced that we didn't want images that were polished digitally, even in post production. We wanted a real piece of film from a real aeroplane in real flying conditions. Maybe it's nostalgic – the smell of aviation fuel and the noise of the engine when the plane takes off. So much of what we see today is digital perfection.

SW: There is the idea that digital images are part of the mechanisation of sight, the hijacking of sight by 'vision machines'.

DC: And it isn't just that – we wanted to go through a more complex process, of convincing a retired Air Vice Marshall to use his flying skills in a restored ex-Red Arrows jet to draw an Anarchy symbol in the sky. We could have got something convincing with digital technology, even

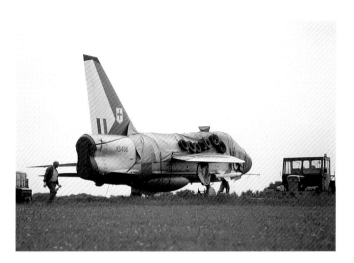

with rough edges and 'errors', but it wouldn't have had that process of engagement with the forces of conservatism which I value so highly.

MC: Doing all this for real is frustrating in some ways but a great thing about it is that what you get becomes inevitable; once it's set up you have to go with it.

DC: So we often work with people whose expertise and knowledge seems initially quite odd, yet their world is absolutely normal to them. When we visited the air base at Cranfield we realised that it is a hyper-masculine environment; there are virtually no women present, it is all men speaking mainly in technical terms about the very clearly defined objectives which relate to the maintenance and use of these aircraft. It's as though there is a code, an unspoken agreement, to exclude anything feminine. Yet although this is suppressed, there are signs of it returning everywhere which they seem blind to. It is a very odd environment really. A connection between *Childhood's End* and an adolescent phase comes out. These are fully-grown men but being among them is a bit like being in a teenage boys' club.

MC: That's absolutely the case. I think that these men were enthusiastic to be involved in our project because it legitimised what they otherwise do or read about only as a hobby. The reason for helping with our project was not actually as important to them as somebody saying 'it is OK to do this'. One of the more extraordinary things on this air base is the man who owns a Lightning jet, which was a front-line fighter in the 1960s. As the Civil Aviation Authority don't allow the plane to fly, he will taxi it around the airfield with both engines running every couple of months, which might cost him a thousand pounds in aviation fuel. The rest of the time he is just servicing the plane. It's a very strange way to spend the weekends.

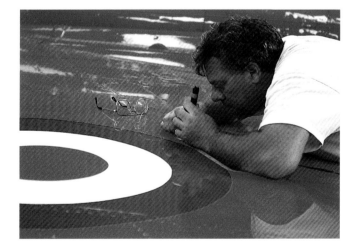

DC: There is an atmosphere of readiness and preparation. As soon as something comes in which is like a mission or objective, a lot of attention gets devoted to it as it justifies the work they've put in.

SW: So there's a lot of caring and devotion in this activity, caring for the machine. The state of being prepared is central to military logistics, so this hobby is an example of the influence of the military in civilian life.

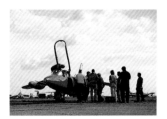

MC: It's an odd recreation because most of the people who are involved with these aircraft – the mechanics and engineers – will never fly them, or even fly in them. The plane we're using has a full-time crew of about four people. It is a distinct social hierarchy on an airfield, with the pilot as the knight and the ground crew as retainers servicing the plane.

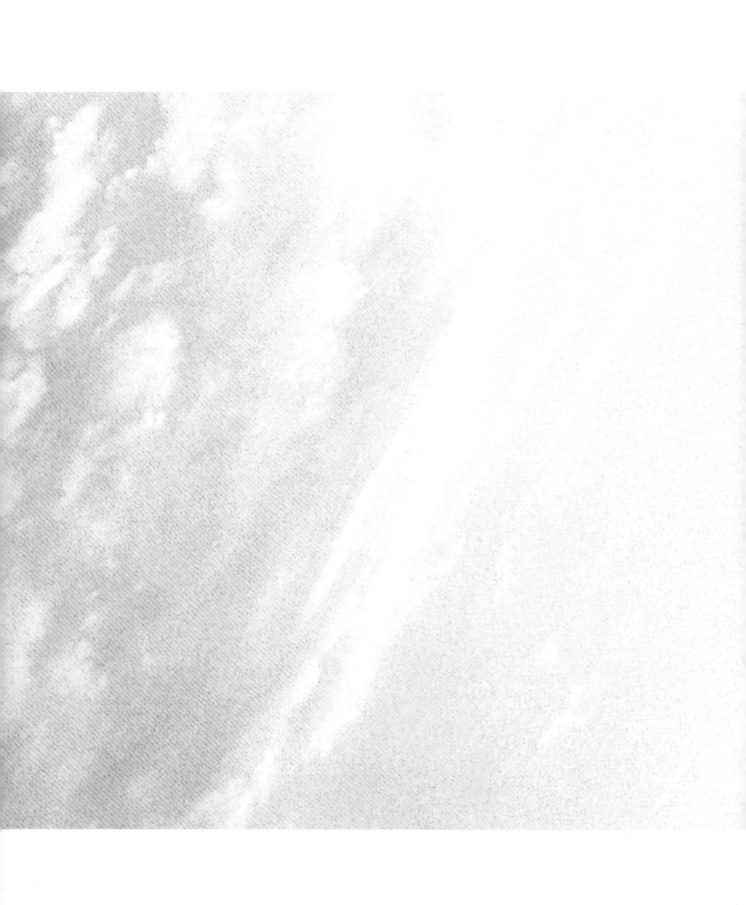

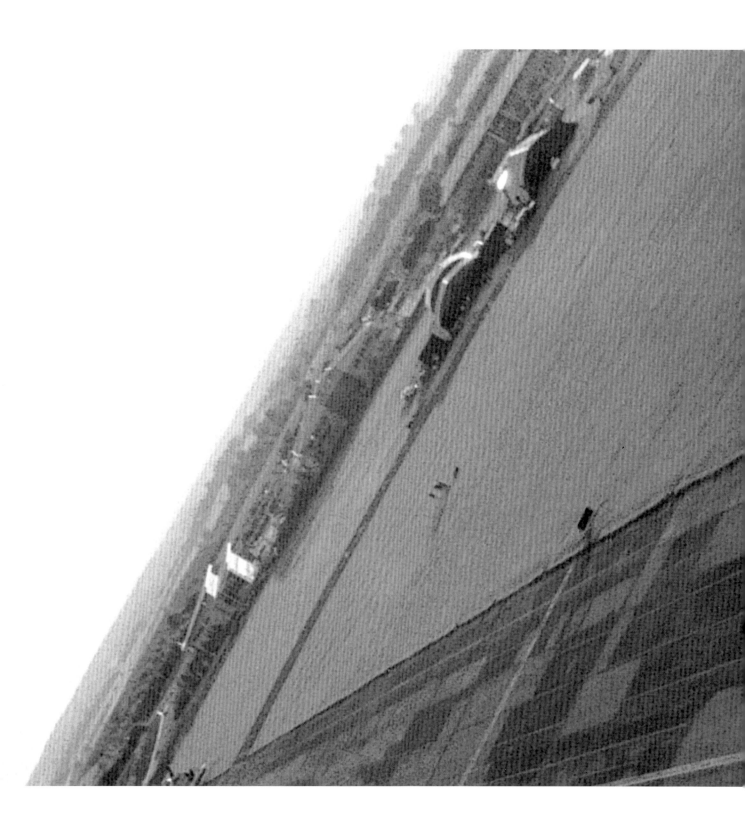

previous pages:
Childhood's End
2000
16mm film still

opposite:
Childhood's End
2000
production still

'Airfix' model kit
2000
artists' archival material

DC: What we're dealing with at Cranfield is not the Royal Air Force, not a system and hierarchy which is imposed. The people we're involved with are voluntarily subjugating themselves to this social system.

SW: The support and social structures also seem comparable to that around a motor racing team, another hyper-masculine environment, with many engineers and mechanics servicing one or two cars and with the driver at the top of the social hierarchy. It is interesting that the enthusiasm and devotion is focused on restoring historic aircraft, jets from the 1960s and 1970s; like people working on steam trains – refurbishing and maintaining them.

DC: You're quite right, there is a quality of the 'restored classic' club about it. As soon as something is safely in the past it is a knowable quantity; not only is this jet a machine that can be bought but it can be analysed, controlled, catalogued, stripped down and re-assembled. The Hawker Siddeley Gnat we're using has the excitement of jet propulsion and the glamour of its 'Red Arrows' history but it also has the certainties of being a 'classic' from a period in the past which cannot be changed, although this is an illusion of course.

MC: The development of a fighter aircraft is extraordinary because they are so expensive and the lead times can be decades. The type of jet we are using may still be a front-line fighter in poorer nation states because once replaced in the Royal Air Force they are sold to other countries.

SW: Would it be true to say that you admire that enthusiasm, that specialist knowledge, those skills and some aspects of the technology?

DC: I think it would, yes. From a distance it is far easier to be critical, but it is very hard not to get drawn in when you're on site and see their level of intensity and involvement. It is also a very exciting environment.

MC: That happened with *Jerusalem*. There are some very pointed critiques in that piece of work but for anybody who has grown up building model kits and playing soldiers, there is something very seductive about buying a full military kit, including an SA 80 assault rifle, which is what we had to do for that piece. These jet planes are like 'Airfix' kits but life-size.

DC: Although the objects and materials that we use are often

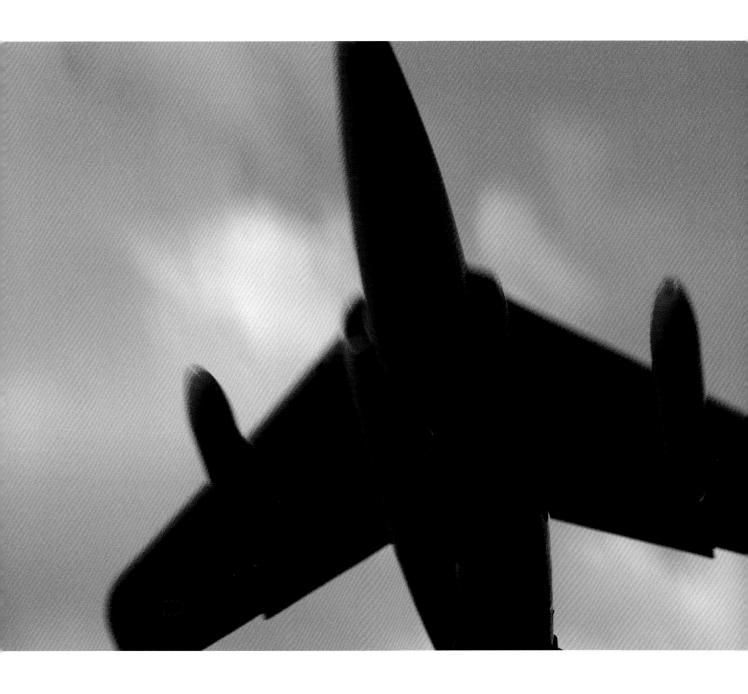

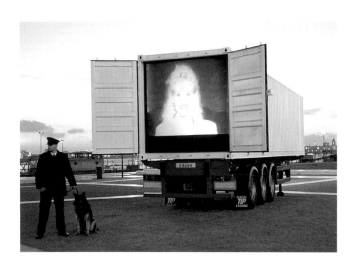

Cosmopolitan
(outdoor version)
1998
steel shipping container, sound
system and video projection
40 x 8 x 14 feet
for 'ISEA '98'
Pier Head, Liverpool

Camelot
1996
installation view
palisade steel security fencing
110 x 3.5 metres
for 'City Limits'
Albion Square, Stoke-on-Trent

absolutely standard, it is important that we select the right one from the system of manufacture and construction.

MC: For *Camelot,* where we built a fence around some neglected fragments of land, we spent a long time deciding on the type, height and quality of steel for the fencing we wanted to use. It was a standard production fence but there are an awful lot of such fences to choose from. We were particularly keen on the one we used for aesthetic reasons.

SW: That was the case with *New Holland* as well?

DC: We were very careful about that. We wanted exactly the right shade of grey for the polyester-coated box section European profile pressed-steel covering for the steel frame. We spent a lot of time going out to photograph similar structures, going through catalogues, and sending off for samples.

MC: One of the things we spend most time on is trying to get the right fence, television set, jet aircraft or whatever it is that we need. It is surprisingly difficult to do. For *Cosmopolitan* (1998) there were lots of different types of truck and shipping container but we wanted the most standard, the most uniform. That is important to us for the reading of the work.

SW: Although you admire the specialist skills and knowledge and there is a close attention to the materials you are using, the work is not a celebration of the technology.

DC: It is a fairly problematic line we tread at times. We do find the systems that we critique seductive, which is perhaps why they are so interesting. They are dangerous and appealing at the same time. If they were simply dangerous and repugnant they would not be interesting or suitable for an art project. It is the uneasy combination of the aesthetic appeal, the visceral thrill, with the distance, or political opposition, to the way foreign policy might direct the use of force, for example, the way a democratic society might be co-opted into a questionable conflict. You can be critical of the dangers and still think 'that's a beautiful plane, it makes an awesome sound, cuts an elegant curve through the sky'.

SW: Virilio identifies links between military systems and entertainment systems, between the war machine and the observation machine, as he puts it in *War and Cinema*. He cites Howard Hughes as someone who exemplifies such links, being involved in both the production of films and of missile guidance systems. Does *Childhood's End* explore similar links?

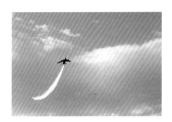

Childhood's End
2000
production still

following page:
Childhood's End
2000
digital video still

MC: Absolutely – a core part of the project engages with the aerobatic display as a form of public spectacle which bypasses critical thinking and popularises militarism.

SW: Although your work highlights systems and structures that are dominant, aren't there also elements which indicate strategies of resistance? For example, the music in New Holland is related to a contemporary use of the countryside for weekend Raves. The Anarchy symbol in *Childhood's End* might be read as signifying that resistance is still possible within a restricting, confining system.

MC: We don't believe that, though!

DC: It might suggest a yearning for some possibility of resistance. There is a very swift process of incorporation. We included House and Garage music in *New Holland* as a sign of youthful rebellion, resistance and transgression but it was contained within a manufactured steel structure, which was situated on the lawn of a cultural establishment (The Sainsbury Centre for Visual Arts). In cultural practice little flexible openings appear – to renew itself the mainstream requires some rebellion that it can draw into the centre and rejuvenate itself. So we keep looking for new opportunities and enjoy them while they last but recognise that they're permitted transgressions.

SW: Would you agree with a Virilio aphorism that : 'It is necessary to obey but also to resist'?

MC: I think maybe that's what we are doing! We have to work within rules, structures. The world that we work in has rules that allow a steel barn with House music on a site that normally you would never get permission for, as it's an art project. So, as David said, it's transgression within allowed parameters.

DC: It's like a cultural equivalent of diplomatic immunity. It is very tightly prescribed and bounded but there's an elasticity so you can push the boundaries of what's permissible. As long as you obey certain rules you can transgress others way beyond what might be expected.

MC: I think texts play quite a role in that. If we can produce a sheet of paper with something coherent written on it, all sorts of things can happen. It seems to reassure people if they see something in writing. I think exhibition catalogues are about that, to an extent. They are a way of making something safe; if the work is rationalised, it gives spectators an understanding of the work, which is therefore less threatening.

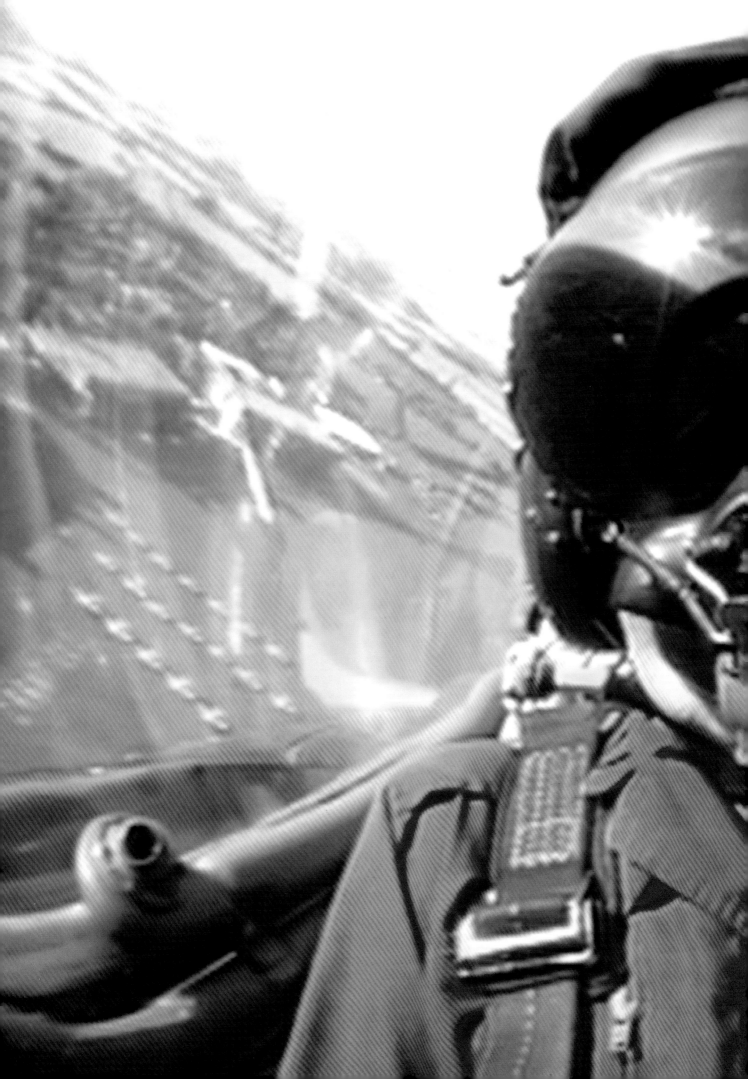

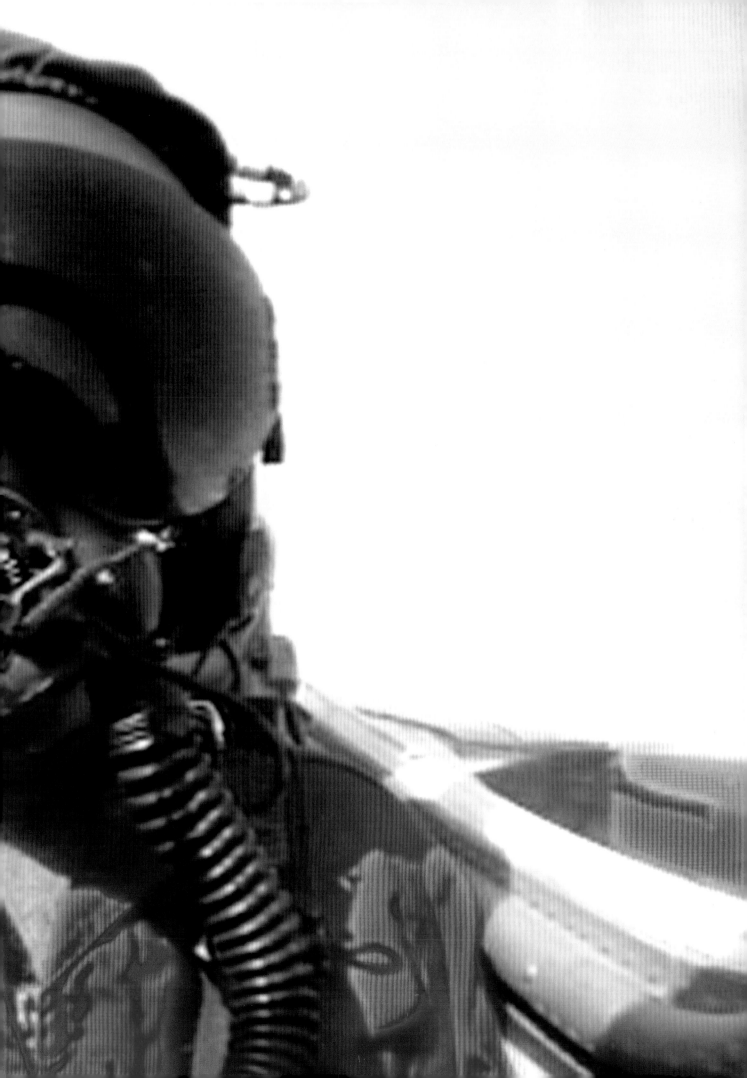

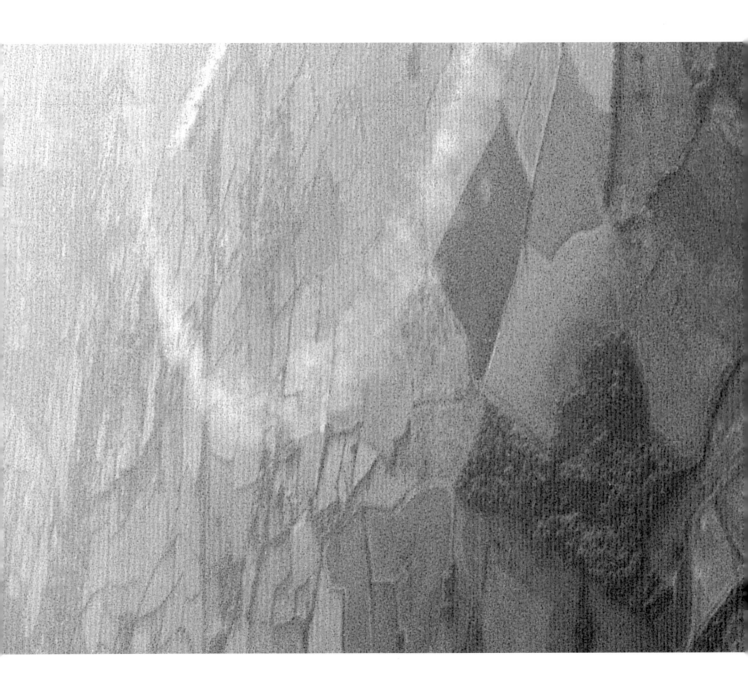

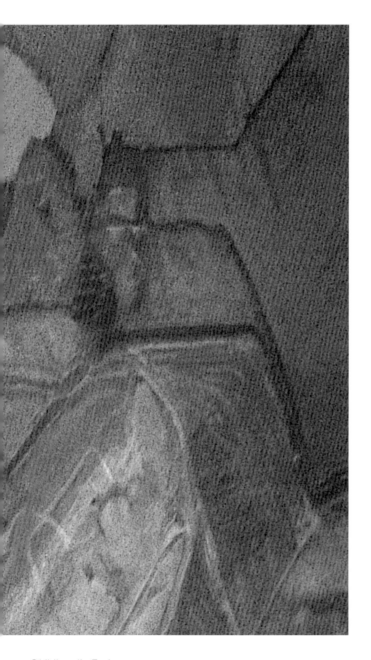

Childhood's End
2000
16mm film still

SW: Occasionally your work gets taken up and supported by the institutions, social structures, systems that it aims to critique; *Jerusalem,* for example.

DC: I worry about the risk of compromise. Our installations are the result of a process of close involvement with each context. In a sense we're conducting an experiment to see whether the institution changes by absorbing the piece of work; in doing so our understanding of the institution is enriched and we are affected as a result.

SW: Your work often brings together systems and social structures that wouldn't usually be linked. You use structures, conform to structures, like the funding structures for example, which determine that the 'outcomes' of the project meet certain criteria.

MC: Those criteria are agreed to an extent, and fixed by us in a written statement of our aim. So the text is always written before the piece is produced, though it might get refined as the project develops.

DC: We can only realise our work by squeezing it through the gaps between the various institutional structures, systems and the boundaries of their power. When we wrote the text for *Jerusalem* the dilemma was: do we write one text to convince the Headmaster of the public school that what we're doing is 'pukka', that we're officer material, and then other texts for the curators and critics? But as with all our projects the text remained the same for whoever is involved.

SW: The title, 'Childhood's End' is taken from the Arthur C. Clarke novel. Are there links between your project and Clarke's work beyond the use of the title?

DC: Tangentially there are. The attainment of maturity in that book is equivalent to letting go of morality. There is a paradox there, an ambivalence which we like. There is no direct thematic link or narrative connection between Clarke's novel and our work but the propositions have an equivalence.

SW: About a week before the filming you decided to use one aircraft rather than two to sky-write the Anarchy symbol. Was that mainly a practical decision?

MC: Partly. The number of variables in running two aircraft increase and there are real costs involved in flying jet aircraft with cameras on board.

33

Paperback book
Pan Books Ltd
London 1956
artists' archival material

Childhood's End
production drawing
ink and pencil on paper

Childhood's End
2000
digital video still

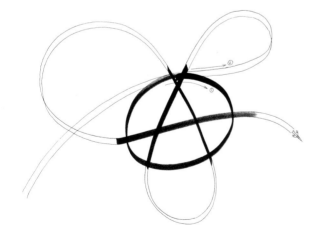

DC: The complexity of synchronising two aircraft would have put a lot of pressure on the fifteen minute flying slots. But we also thought, actually this is writing. If somebody were to go along and graffiti the side of the law courts with the Anarchy sign, there wouldn't be one person doing the circle and another doing the 'A'. One person does the whole thing.

MC: We'd decided on the installation by that time, with the small screen shot of the pilot flying the plane and the large screen showing the infinite space outside the aircraft, so two aircraft seemed to duplicate and unnecessarily complicate the filming and sky-writing.

DC: When we decided to select a single roll of film something else emerged. If you imagine the path of the aircraft as a three-dimensional model and couple that with the idea of the spool of cine film unwinding as it's exposed during the flight, there is a spatial element which editing would have disrupted. Having screened the two sets of footage in the same space, we decided to play the video of the pilot backwards. This disturbs the viewer's perception of space and motion, and closes the linear aspect of the aerobatic gesture into a kind of infinite loop. Patterns emerge when drawing out the relationship between the spirals of tape and celluloid unwinding, and there's an interplay between the direction of each camera, the movement of the plane and the passage of time.

SW: **From viewing the film the spectator will have no idea that the Anarchy symbol was the central configuration of the pilot's manoeuvre. Did this element become less important to the project or does its invisibility in the film perhaps reinforce the futility of the gesture?**

MC: By not showing the symbol we increase its importance and oblige the viewer to make a leap of faith in believing in its existence.

DC: So not only do viewers have to 'edit' the film for themselves, they have to mentally 'project' the key element.

MC: Once we let go of the need to draw a perfect Anarchy symbol we were able to accept whatever we were going to get from the day of filming. Within the film there are clearly bits of smoke which are partial glimpses but a moment came when we decided there is not going to be a complete circled 'A', digitally enhanced or otherwise. What is interesting is that people then began to say 'I want to see an Anarchy symbol in the film'. We've had similar responses in the past, to *Jerusalem,* where access is restricted and to *Camelot,* where people became very indignant that they couldn't get to the piece of land.

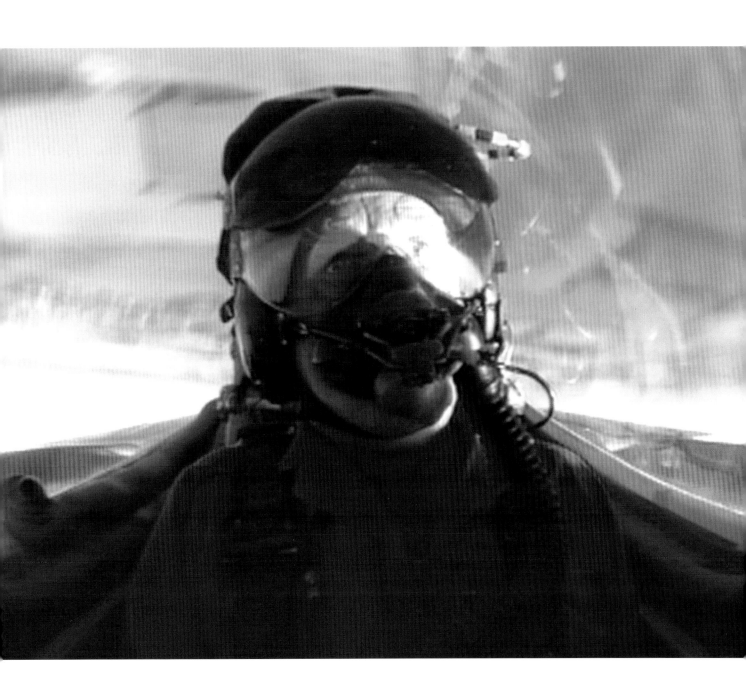

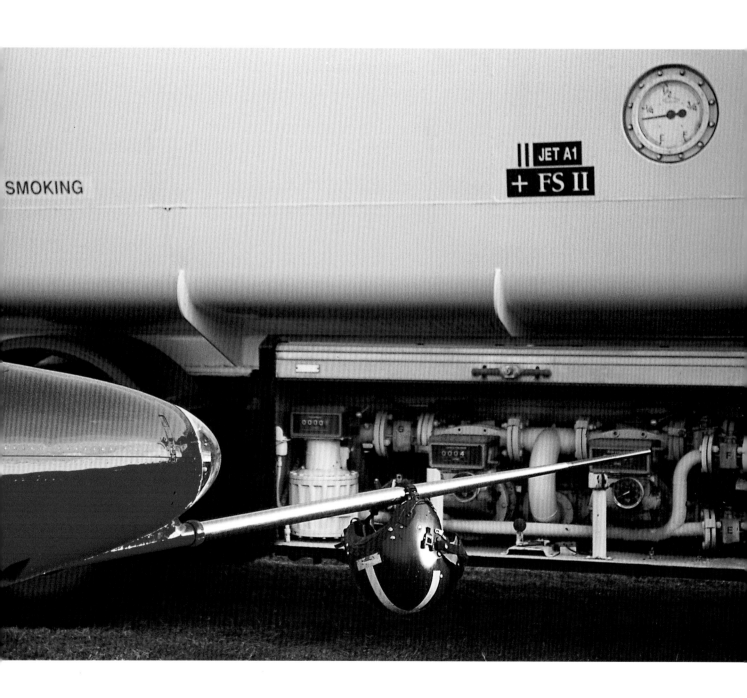

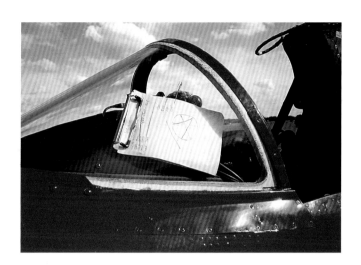

Childhood's End
2000
production stills

SW: Did the pilot, the retired Air Vice Marshall, ever ask about the Anarchy symbol, the artwork, the installation?

MC: No.

DC: Not a word. It seems to be a military thing. You're either friend or foe, either you're in on the job or you're not. If you agree to the job the focus is on the technicalities, and the best way of achieving the objective.

MC: To draw an Anarchy symbol in the sky the pilot has to first plan the manoeuvre with compass bearings.

SW: The pilot worked out the compass co-ordinates on a piece of paper supported on his knee just before he got into the plane.

MC: We can't use the film of the first flight because his compass failed and he was unable to find his co-ordinates, to finish drawing the symbol. Interestingly, if lost, pilots fly a triangle to reorient themselves.

DC: We have that footage and it is beautiful but it wanders, it strays. The take when the compass is operational has a precision and restraint. That is the film we are using, with the sun setting.

MC: Things going wrong, like the compass not working, are part of the experience of doing this.

SW: Despite all the systems of checking the aircraft and the regulations regarding flying, the controlling mechanisms, it seems to me that the pilot must be able to improvise based on his or her training, to respond to the changing conditions of the flight. The relationship between control and independence is a significant theme of *Childhood's End*.

DC: One of the things that interests me is that in the military the outer appearance is one of total order but actually what goes on is far more fluid and flexible. As in so many systems, if everything were carried out to the letter of the regulations the system would cease to function. It is human goodwill and an excessive identification with the overall system, the morale thing in a way, which maintains the system. So there is a play-off between what is imposed and what is voluntarily accepted. It is the harnessing of these two things, which are always going to be incompatible, yet which have to co-exist if the system is going to continue or if people are going to have some outlet for their transgressive desires.

opposite and following pages:
Childhood's End
2000
production stills

Childhood's End
2000
production still

The multiple ambiguities at the end of childhood have been one of the constants since the outset of the project. The idea of *Childhood's End* being the attainment of maturity or breaking away from parental control is one of the things we're dealing with; it's that tension between the attempt to pull away and the elastic boundary which keeps the individual subject in the fold.

SW: The openness and tranquillity of the exterior view contrast to the movements of the pilot and the sense of constraint of the interior viewpoint.

DC: The Super 16mm was 'over cranked' to counteract the vibration of the aircraft and the centrifugal forces acting on it. It is shot at 30 frames a second and screened at 25 frames a second.

MC: The result is that the film shot from the wing camera is very calm.

DC: From the ground we saw the aircraft go past, heard the noise, smelled the exhaust and it seemed very fast and violent, but the footage filmed from the wing is very peaceful.

SW: At times you just see sky, at others there is a patch of earth below which then suddenly shifts 90 degrees and 180 degrees. What is the significance of the landscape in the film?

DC: It's a typically English landscape at the end of a summer's day, with all the connotations of peace, stability and quiet conservatism.

MC: In the cine footage, you can't see the side of the plane so there is only an abstract sensation of flying. The viewer's sense of gravity gets quite disorientated as the pilot changes direction and flies upside down very rapidly.

SW: The spectator's relationship to the landscape seems quite tenuous, as though moorings have been lost, as if the arrangement of space is no longer certain. This is reinforced by the interior view of the pilot looking around and seeming quite vulnerable and fragile.

DC: That recalls an image. After one of the flights the pilot climbed out of the aircraft while everybody clustered around to refuel it, polish it, and check the camera equipment. He quietly walked away to the grass beside the runway with historic aircraft in the background. This very dignified former Air Vice Marshall in a bright red flight suit just lay down on the expanse of green, facing the grass.

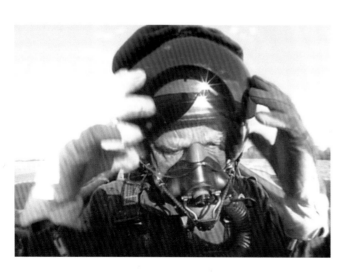

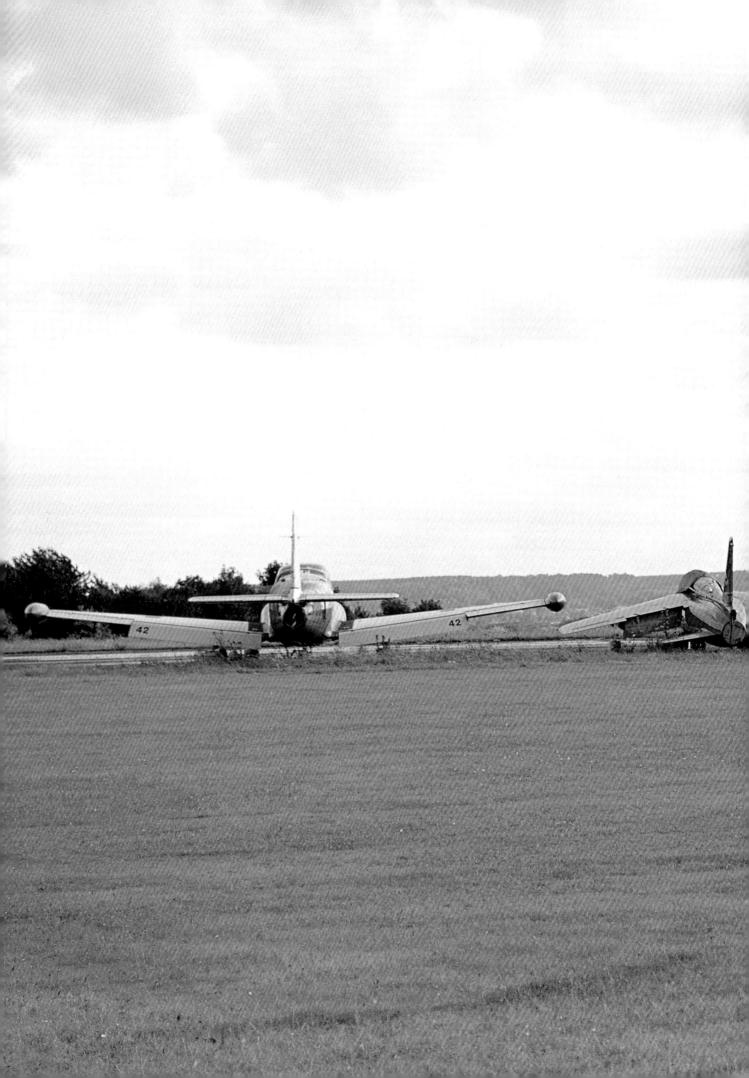

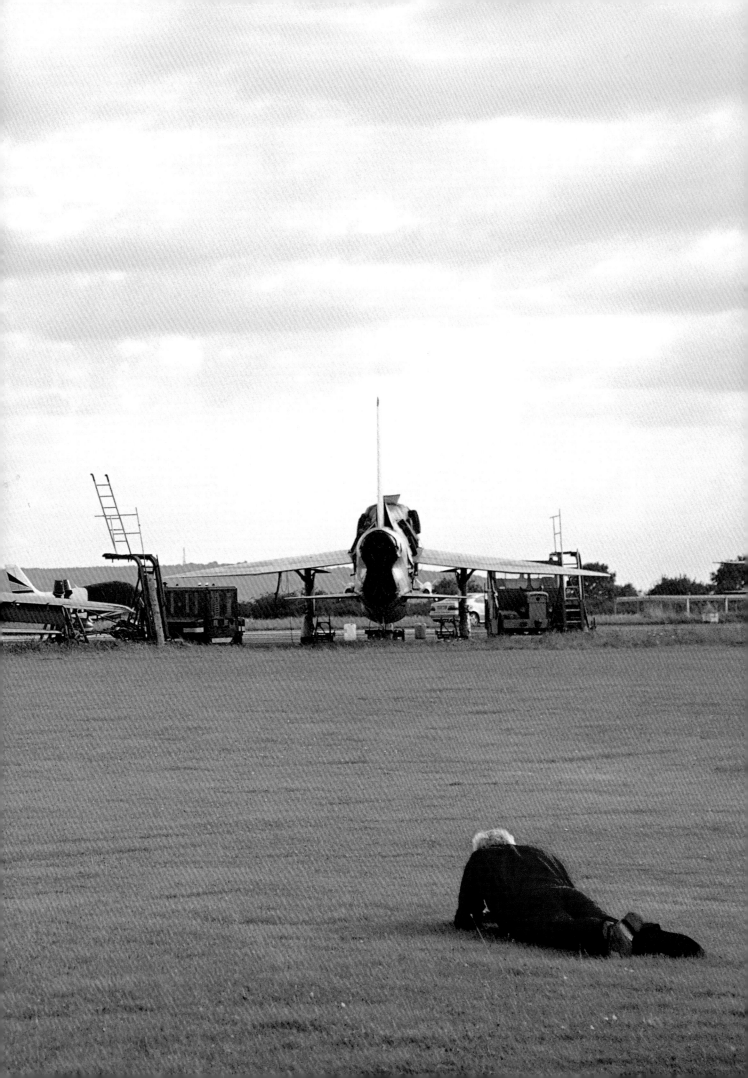

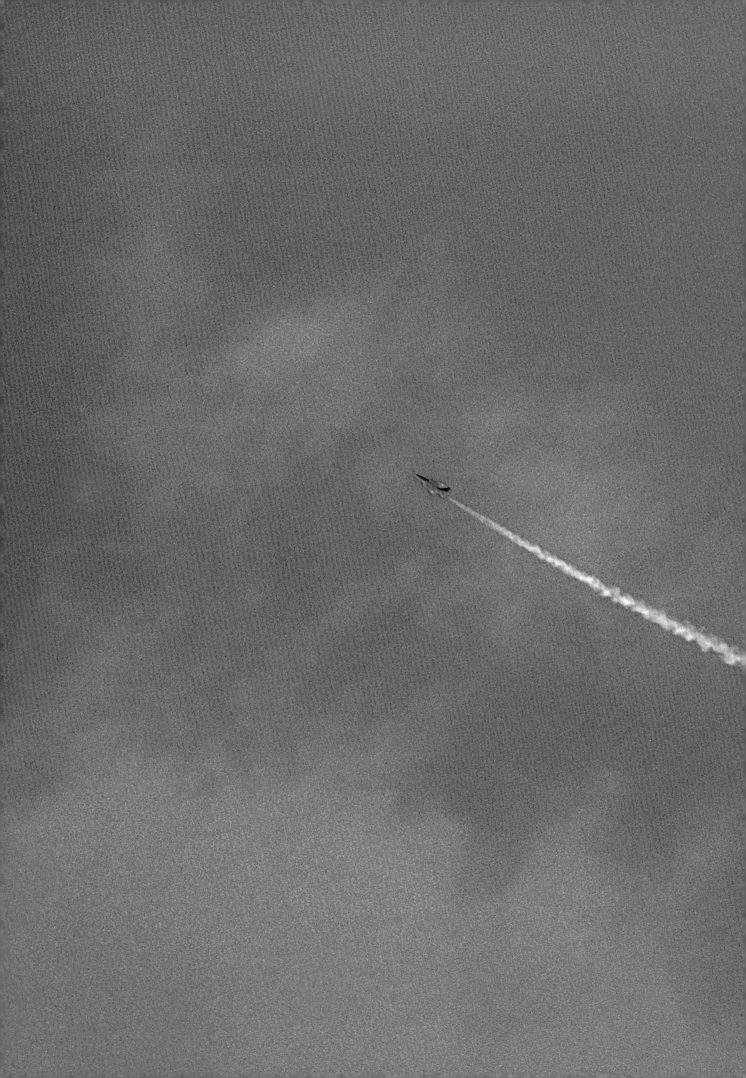

Above, the fulminating roar of the military fighter dopplers into a delicate shimmer of smoke that hangs in the air after the noise subsides — two sides of the airwave spectrum that the plane punches through the sky. Now, as the jet jinks and barrel-rolls through a series of ever more dizzying manoeuvres, its fleeting smoke-trails distract attention from the thunder that it carries in its wake. From the ground, as the aircraft climbs steeply, disappearing into the blue, the line it writes starts to resemble an arc of escape; if only into momentary reverie, into childhood dreams of leaving the everyday world far behind. Flights of fancy, whose hold on the imagination is somehow all the stronger for the fact that they last for only as long as it takes for the smoke to disperse.

The gallery installation *Childhood's End* by Cornford & Cross revolves around a visual document of one such aerobatic manoeuvre, performed by a Hawker Siddeley Gnat jet over England in the summer of 2000. The flight is captured from a 16mm camera strapped to the front of the plane, in the position of the weapon platform. Despite this conceit, the resulting six-minute film, blown-up to cinematic scale in the gallery, looks nothing like the now-familiar fuzzy video footage looking down the barrel of a missile homing in on its target. Its vivid, almost dream-like texture accentuates the sense of wonder and freedom that is at the heart of our experience of flight. The sequence finds its counterpoint, however, in a shot of the same manoeuvre presented, on the opposite side of the gallery, on a miniature video monitor; this time looking back into the cockpit of the aircraft. This footage of the pilot reverses the temporal order of the other sequence, beginning a series of deftly mirrored oppositions that reverberate throughout the work as a whole: between the euphoric, oceanic vista opened up out of the front of the plane and the cramped, claustrophobic nature of the pilot's physical situation; and, more generally, between images of freedom and the way they are subsumed within an overarching, self-denying and necessarily limiting system.

These oppositions are magnified when it is disclosed that the figure the aircraft traces in smoke is many people's idea of the ultimate image of freedom — the circled 'A' of the Anarchy symbol. Although it is an amusing irony having the universal signifier of chaos and uncertainty graffitoed in the sky by one of the premier icons of the established order, it is, arguably, not one that can sustain the work over more than one or two repeat viewings. So, rather than sign off the film with the anticipated 'money-shot' of the Anarchy-symbol-as-slogan, Cornford & Cross take the seemingly contrary decision to withhold it almost entirely from view. Seen in momentary glimpses, and pieced together out of fragments, it remains a wholly conceptual figure, at one with its airy insubstantiality: an emblem of

Childhood's End
2000
installation view
Super 16mm film transferred
to DVD
6 minutes 9 seconds
each rotation
for 'Utopias', Mead Gallery,
University of Warwick
photograph by
Jerry Hardman-Jones

turbulence and instability written in, and equally quickly dispersed
by, the wind.

Instead, the work is left to uncover its true subject, which is that of
the loop: a loop of time registered by an unravelling loop of film, at a
particular location on a particular day. As such, the artists might
simply be said to have mobilised the medium of film in the service of
the site-specific, interventionist aesthetic that has characterised
much of their earlier work. What is clear, though, is the extent to
which they have brought that spatial sensibility to bear on the way
the piece is installed in the gallery. To take one example: the figure-
of-eight formed by the two intersecting loops of airplane footage
doubles, intriguingly, as ∞: the symbol of infinity. Locked into a
repeating pattern after transfer to digital video disk, each round of
sky-writing is revealed to exist as part of a larger Möbius loop,
encircling and enfolding the viewer. In this way, with each
successive iteration, the footage of the plane giving the Anarchy
sign begins to appear as less and less of a rogue event and more
as an element in an endless cycle – of order breaking apart and
re-establishing itself; chaotic events, like war begetting peace
begetting war, that, in the wide pan of time, start to seem more and
more like semi-natural phenomena; in the same the way a storm
emerges out of nowhere before washing the air clear again, which
in turn creates the conditions for another storm.

It is here, perhaps, that the artists' decision not to show the
completed Anarchy symbol really comes into its own. Freed from a
potential fate as an all-too-superficially assimilable political slogan,
it haunts the grain of the film as a free-floating philosophical
principle: of the constancy of change and transformation; of the
primacy of uncertainty and paradox. Looping the loop between
order and chaos and back again, Childhood's End is a work that
resists easy closure; open-ended, if not actually anarchic, in its
formal ambiguities and its refusal to be pinned down. In short, it
could be said to hold true to the spirit rather than the letter of
anarchy. Or, to put it another way, even though the 'A' sign itself is
never fully visible, what it signifies is clearly present, shaping and
directing the work.

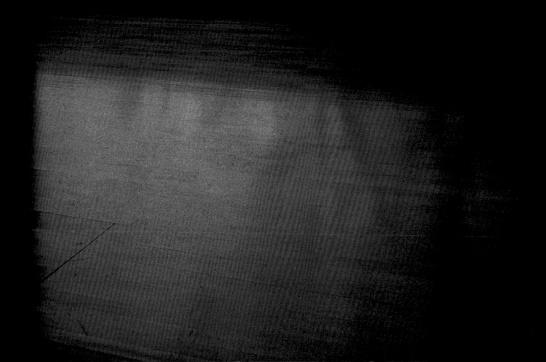

We Three Kings
1997
Christmas card
screen print

2000

Childhood's End
film installation for solo exhibition
Norwich Gallery, Norwich School of Art and Design
18 November – 15 December

'Utopias'
curated by Sarah Shalgosky and Rachael Thomas
film installation, *Childhood's End*, for group exhibition
Mead Gallery, University of Warwick
4 October – 4 December

Cosmopolitan
solo exhibition and outdoor video installation
Nikolai Fine Art, New York, USA
7 September – 7 October

'Let's get to work'
curated by Gavin Wade
two works exhibited in group exhibition
Marcel Sitcoske Gallery, San Francisco, USA
1 April – 13 May

1999
'In the Midst of Things'
curated by Nigel Prince and Gavin Wade
installation, *Utopia (wishful thinking)*, for group exhibition
Women's Recreation Ground, Bournville, Birmingham
2 August – 18 September

'riverside'
selected by Roy Arden and Peter Doig
installation, *Jerusalem*, for group exhibition
King Edward School, Norwich, Norfolk
12 July – 28 August (*Jerusalem* remains in place)

1998
'ISEA '98'
curated by Charles Esche
outdoor video installation, *Cosmopolitan*, for group exhibition
The Pierhead, Liverpool
2 – 7 September

'Cap Gemini Art Prize'
photographic installation, *10,* for group exhibition
Institute of Contemporary Arts, London
11 June – 2 July

'What difference does it make?'
selected by Matthew Higgs, Olivier Richon, Ronnie Simpson
two works from *10*, for group exhibition
Cambridge Darkroom, Cambridge
14 June – 26 July

10
curated by Alison Lloyd and Elizabeth–Ann Williams
photographic installation for solo exhibition
Montage Gallery, Derby
28 February – 10 May

1997
'Oktober 1917 – 1997'
curated by Lynda Morris
video work, *Cosmopolitan,* for group exhibition
Norwich Gallery, Norwich School of Art and Design
1 – 25 October

'EAST International'
selected by Tacita Dean and Nicholas Logsdail
sculptural installation, *New Holland,* for group exhibition
Sainsbury Centre for Visual Arts, UEA, Norwich
12 July – 30 August

1996
'City Limits'
curated by Godfrey Burke
sculptural installation, *Camelot,* for group exhibition
Albion Square, Hanley, Stoke-on-Trent
11 – 27 September

'Something Else'
curated by David Blamey
one work, *Operation Margarine,* for group exhibition
Camden Arts Centre, London.
22 March – 5 May

1994
'Interpretations'
curated by Leo Stable
five works for joint exhibition with Dominique Auerbacher
Folkestone Library Gallery
6 May – 6 June

opposite and following page:
Childhood's End
2000
16mm film still

Childhood's End was co-commissioned by Film and Video Umbrella, Norwich Gallery, Norwich School of Art and Design and Mead Gallery, University of Warwick, and was funded by the Lottery Film Production fund of the Arts Council of England. The project received additional production support from Eastern Arts, Nottingham Trent University and the University of Wolverhampton.

This publication was part-funded by an award from Norwich School of Art and Design, and was published to coincide with the exhibition *Childhood's End* by Cornford & Cross at Norwich Gallery, 18 November to 15 December.

Thanks to: Mike Jones at Film and Video Umbrella; Marie Case at the Lottery Film Department and Gary Thomas at the Visual Arts Department of the Arts Council of England; Alastair Haines and Alison McFarlane at Eastern Arts; Mark Dey at West Midlands Arts; Christian Hogue at Lost in Space; Glenn Furmanski at Frontline TV; Juliet Lawrence at Printout.

Childhood's End was filmed above Cranfield Airbase, England on 1st August 2000. This was made possible with the support of the following: Air Vice Marshall (ret.) Boz Robinson, pilot; Peter Walker, Head of Operations, Kennet Aviation; Tim Manna, Owner, Kennet Aviation; Robert Eagle, Line Producer; Simon Werry, Cameraman.

ISBN: 0-9538634-3-3
© 2000, Cornford & Cross, Film and Video Umbrella, Norwich Gallery, Norwich School of Art and Design

Edited by Simon Willmoth
Designed by Secondary Modern (www.secmo.dircon.co.uk)
Printed by Graficas Varona, Salamanca, Spain
All photographs by Cornford & Cross (unless otherwise stated)

Film and Video Umbrella
Rugby Chambers, 2 Rugby Street, London WC1N 3QZ

Norwich Gallery
Norwich School of Art and Design
St George Street, Norwich NR3 1BB

NORWICH GALLERY

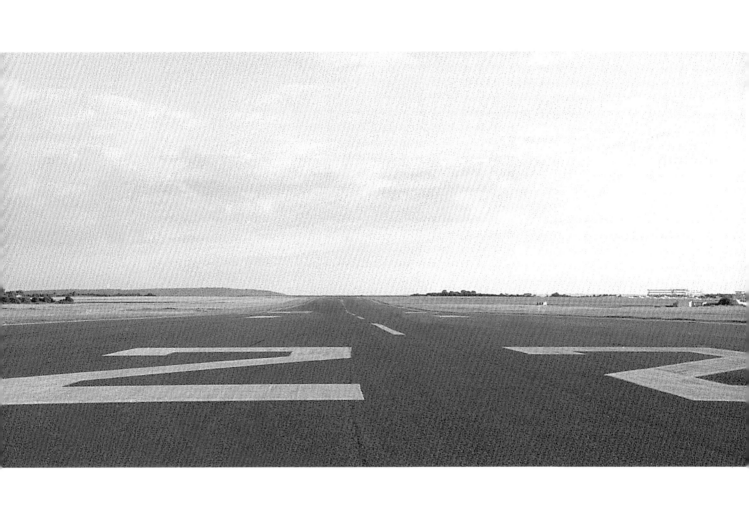

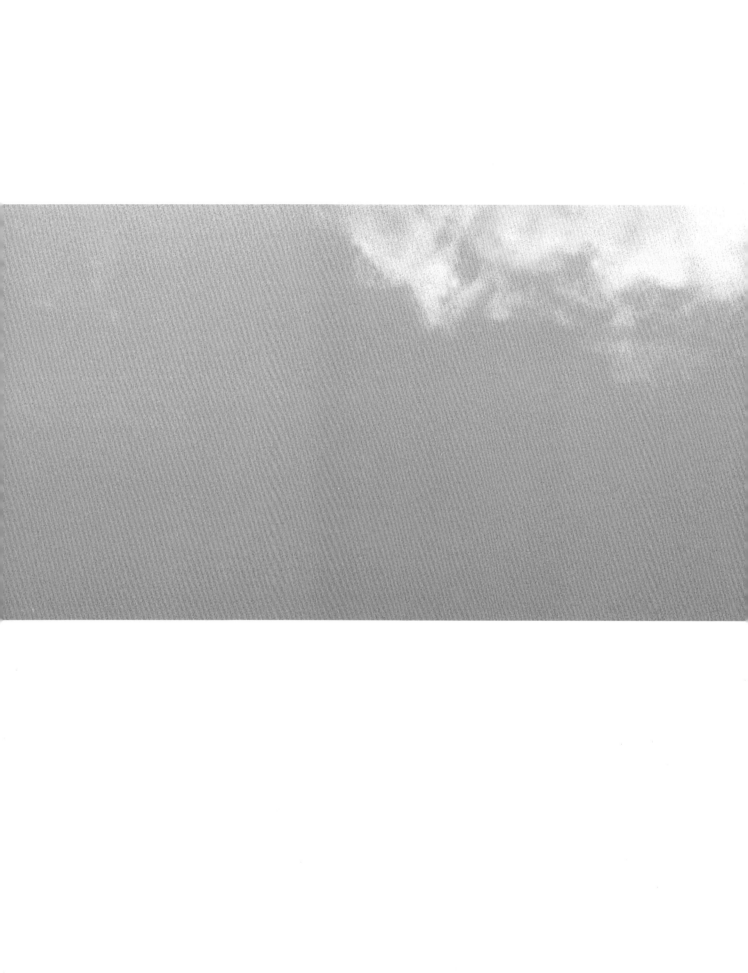